Fucksicles

Swear Word Coloring Book

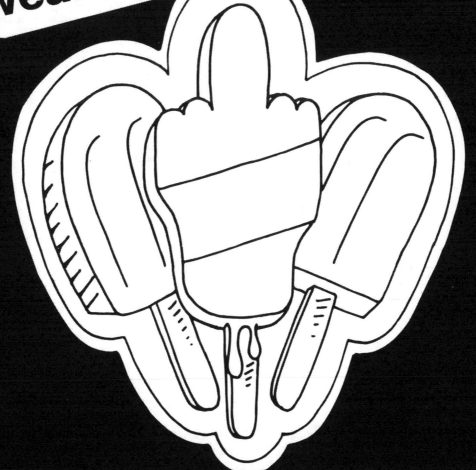

By John T

Assistant Art Director: Siya Oum

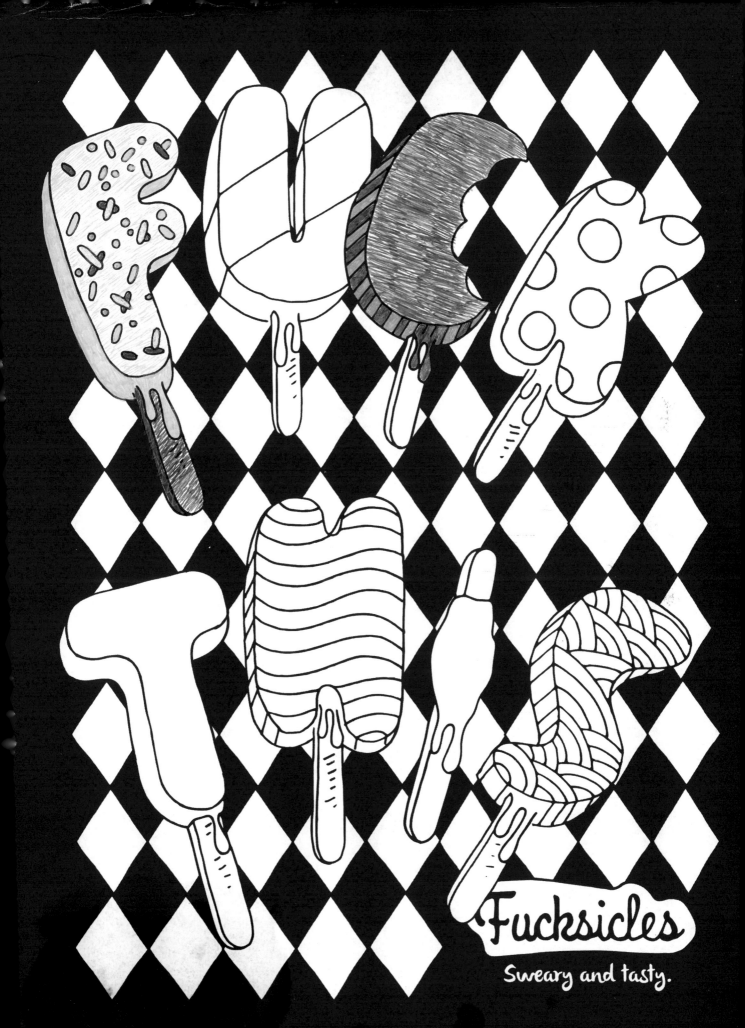

The *Summer Nights edition* of **Fucksicles** is the same as the original, except that it is printed on black paper. Fuck yeah.

Oh, and it has five bonus pages. :)

Use bright markers, neon gel pens, or radiant colored pencils to make your colorings pop.

NOTE: Designs are printed single-sided for your coloring convenience.

Check out **SwearWordColoringBook.com** for free adult coloring pages and resources.

Don't forget to sign up to the email list and receive free goodies from time to time!

Happy fucking coloring.

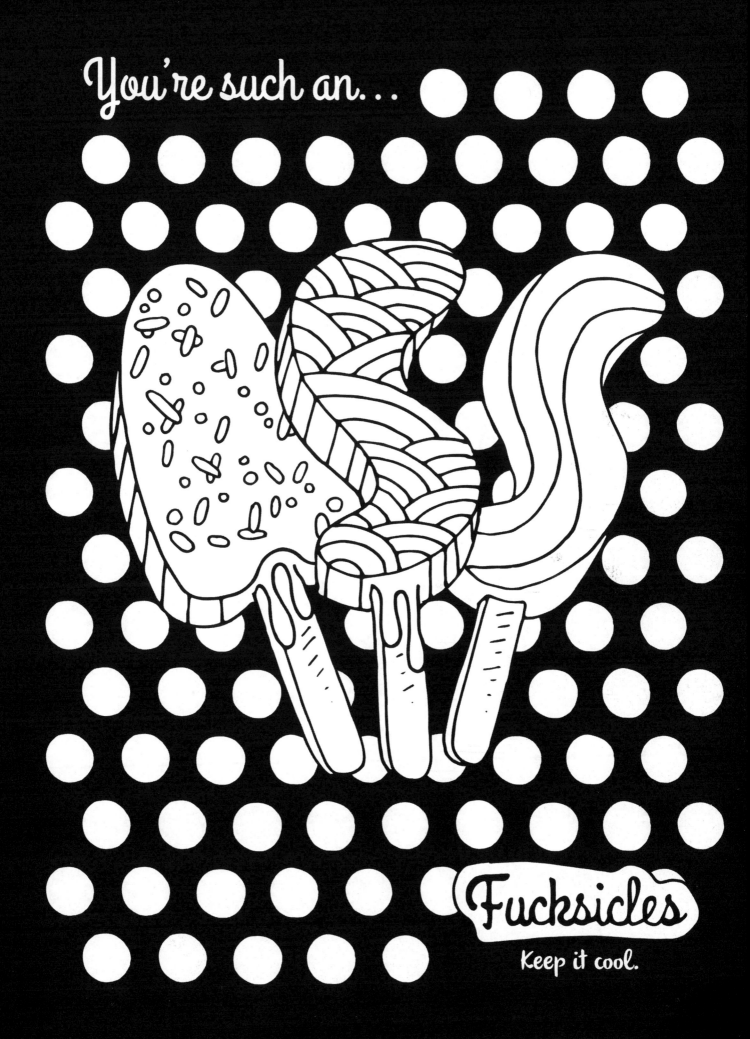

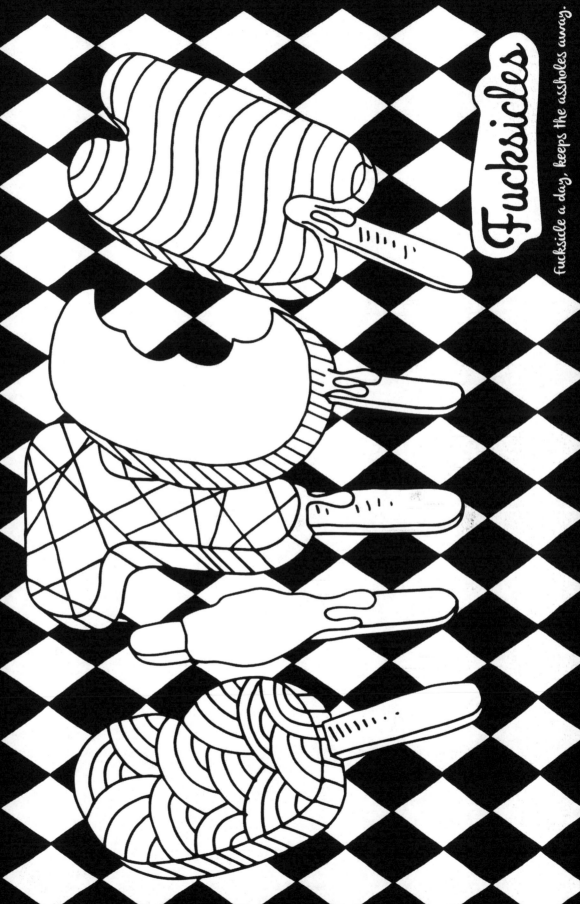

Life's a....

Fucksicles

fucksicle a day, keeps the assholes away.

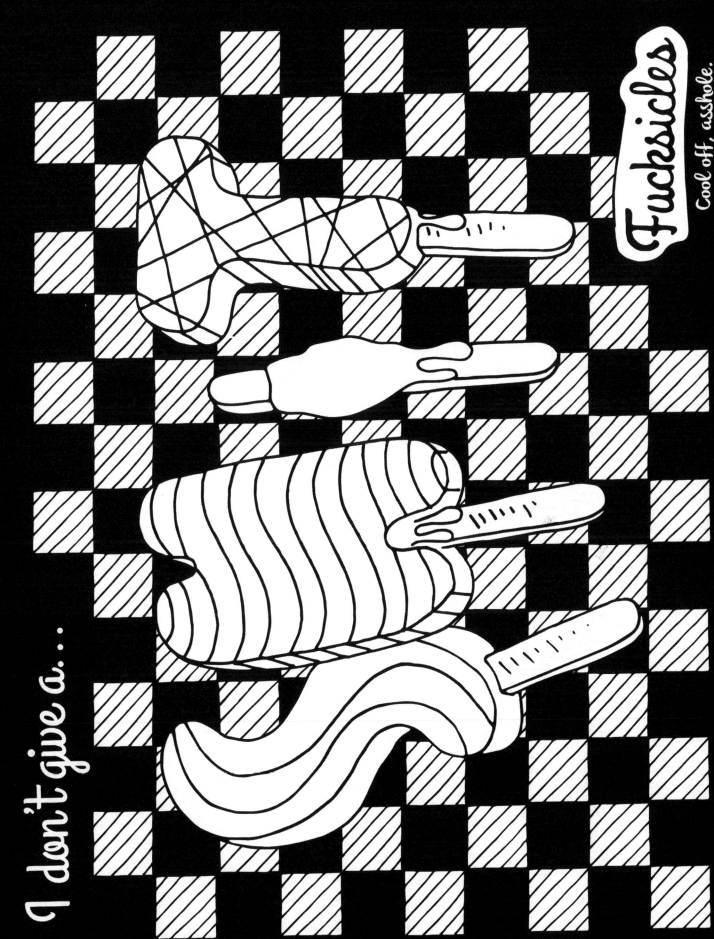

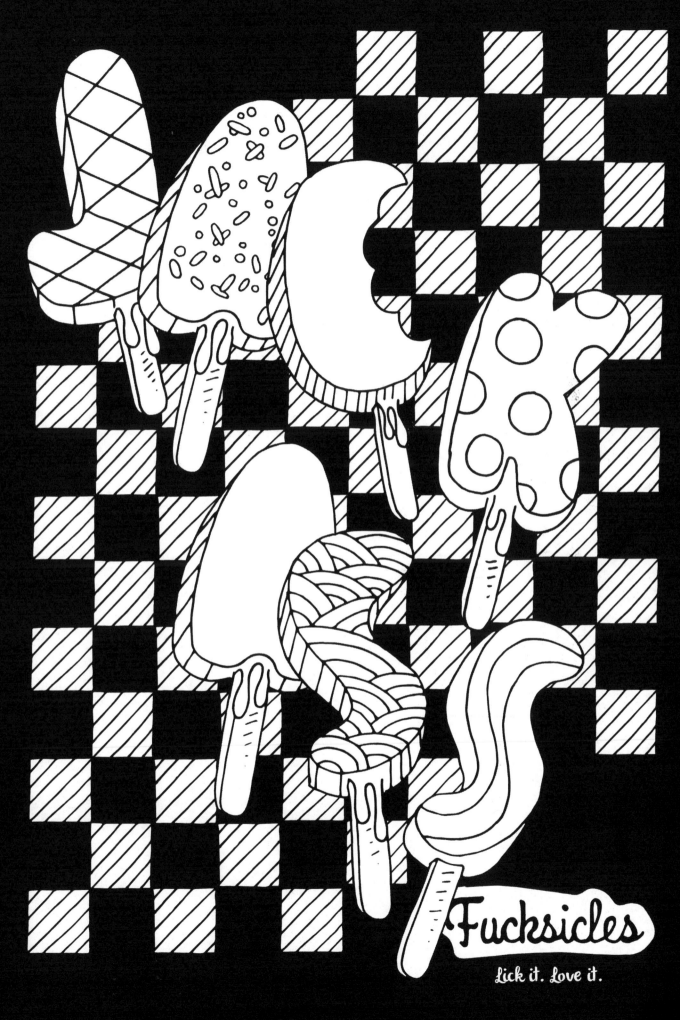

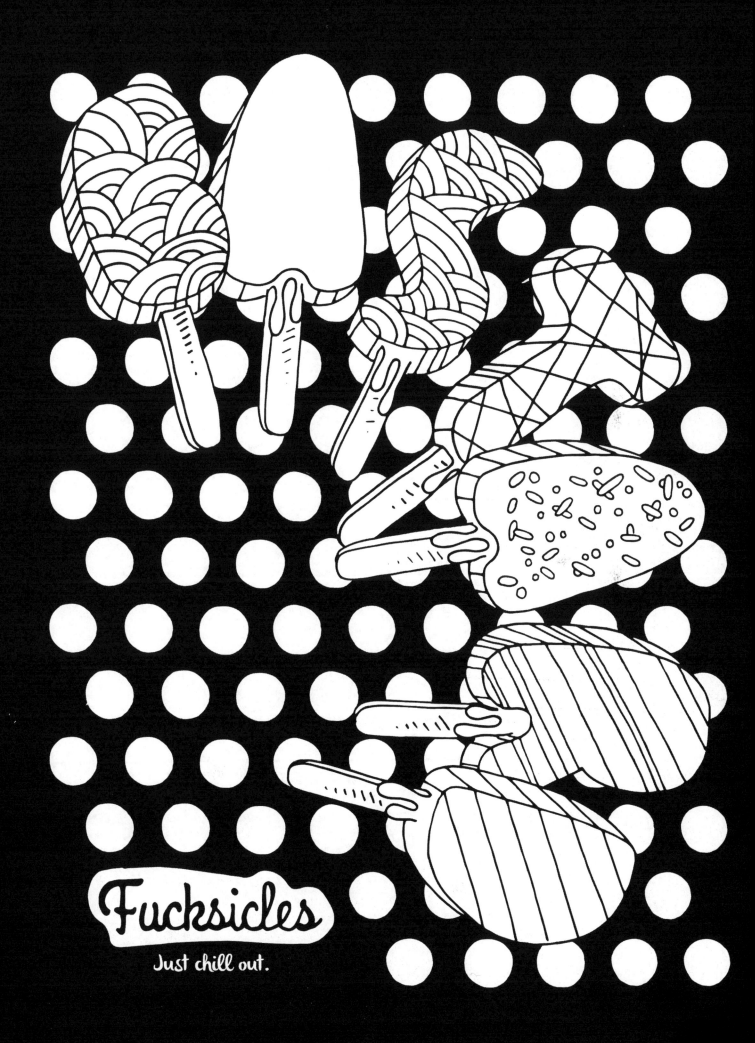

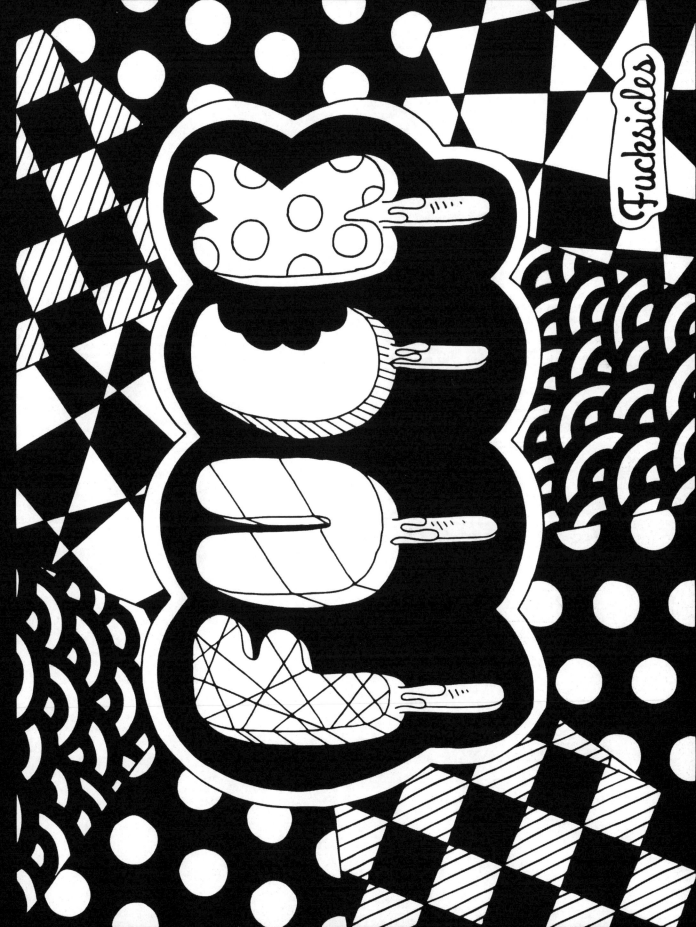

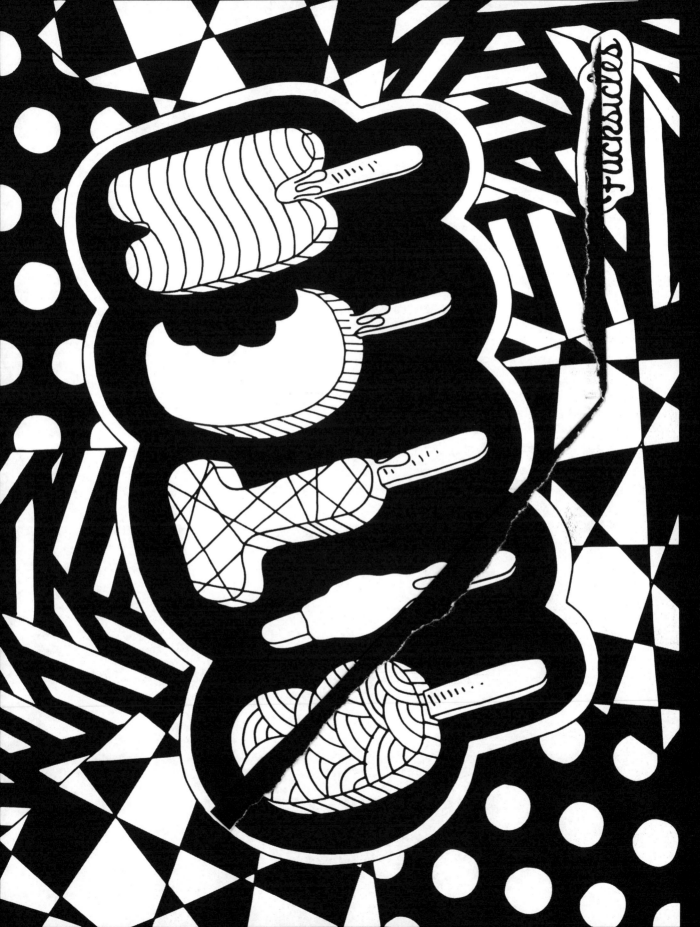

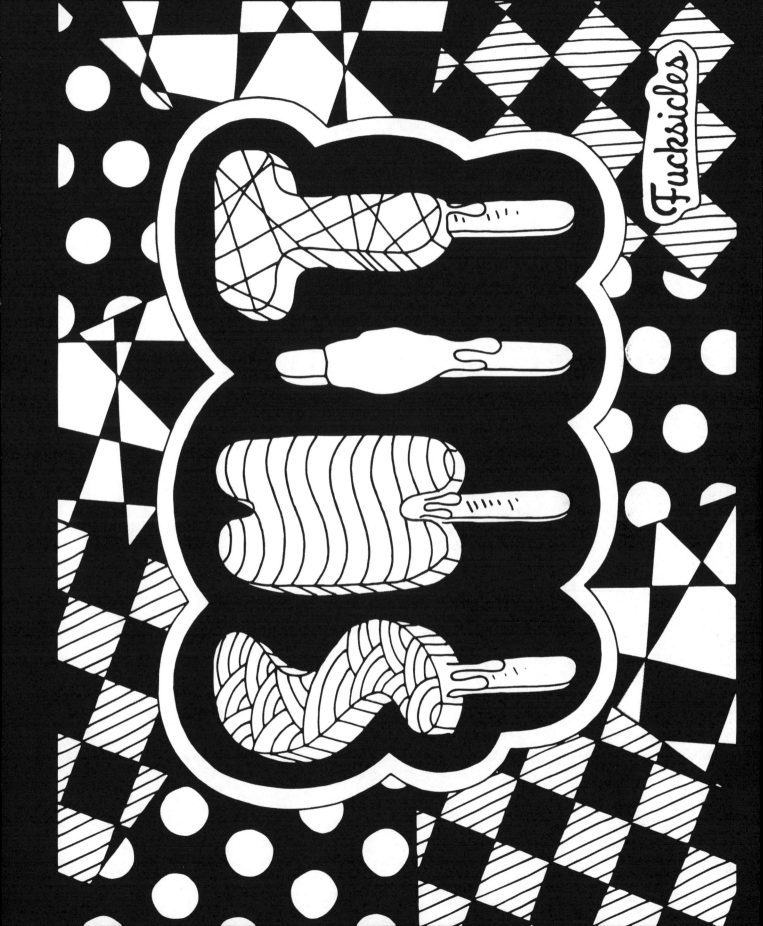

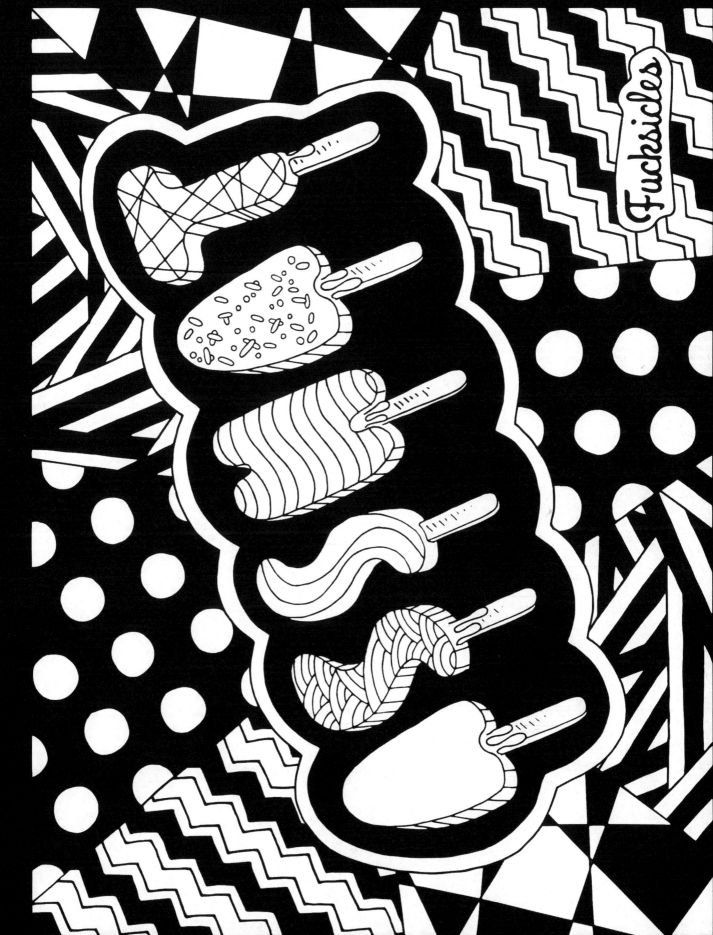

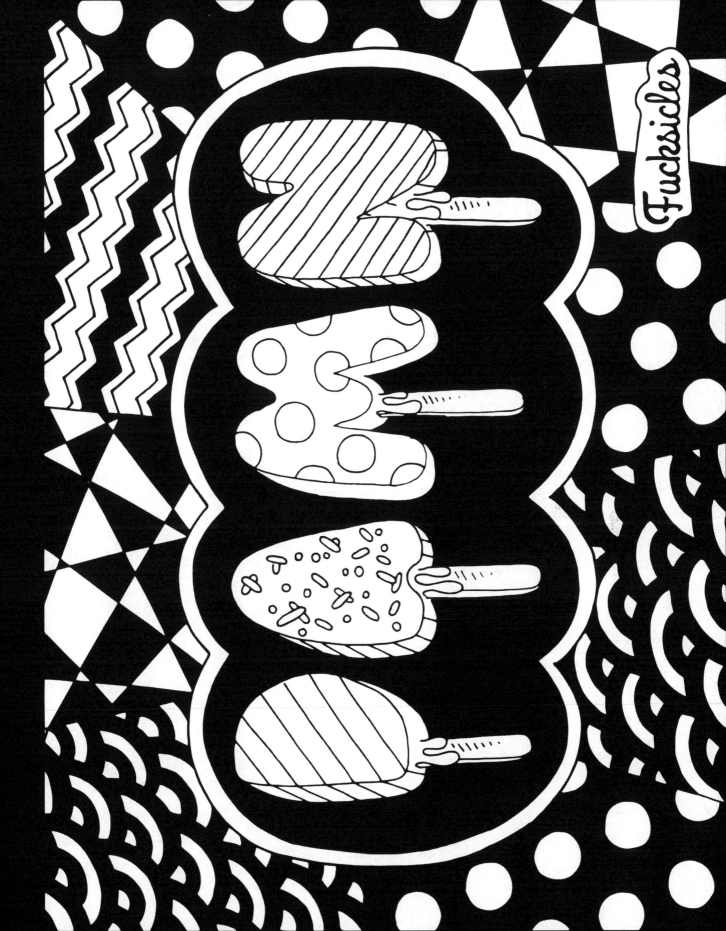

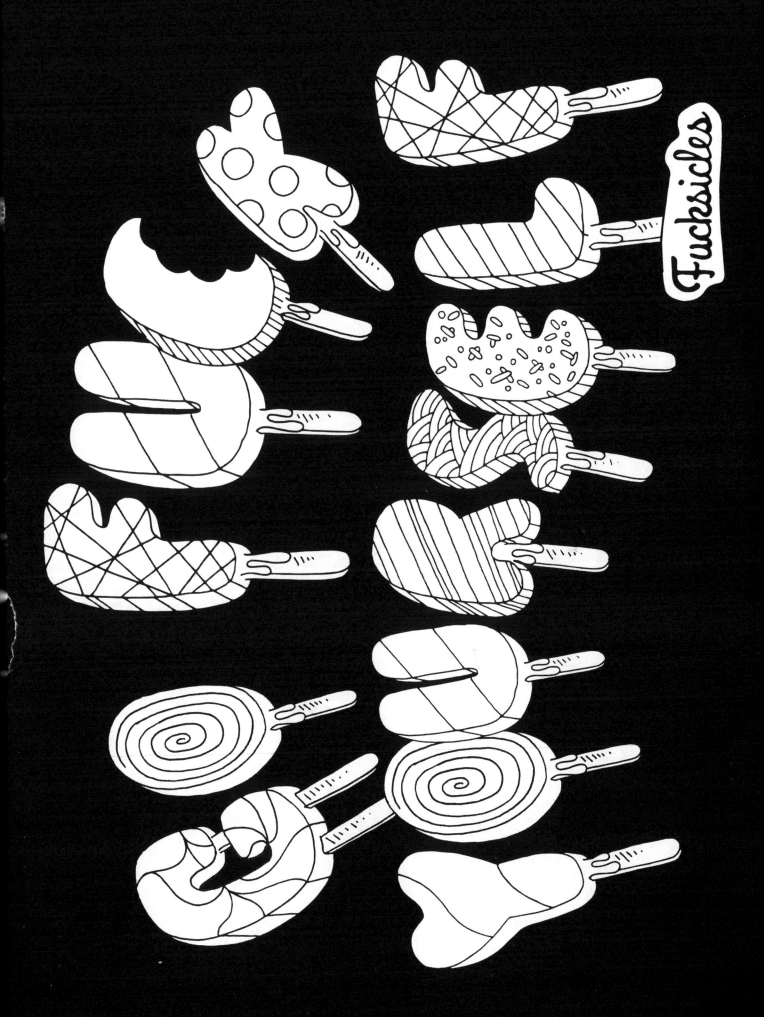

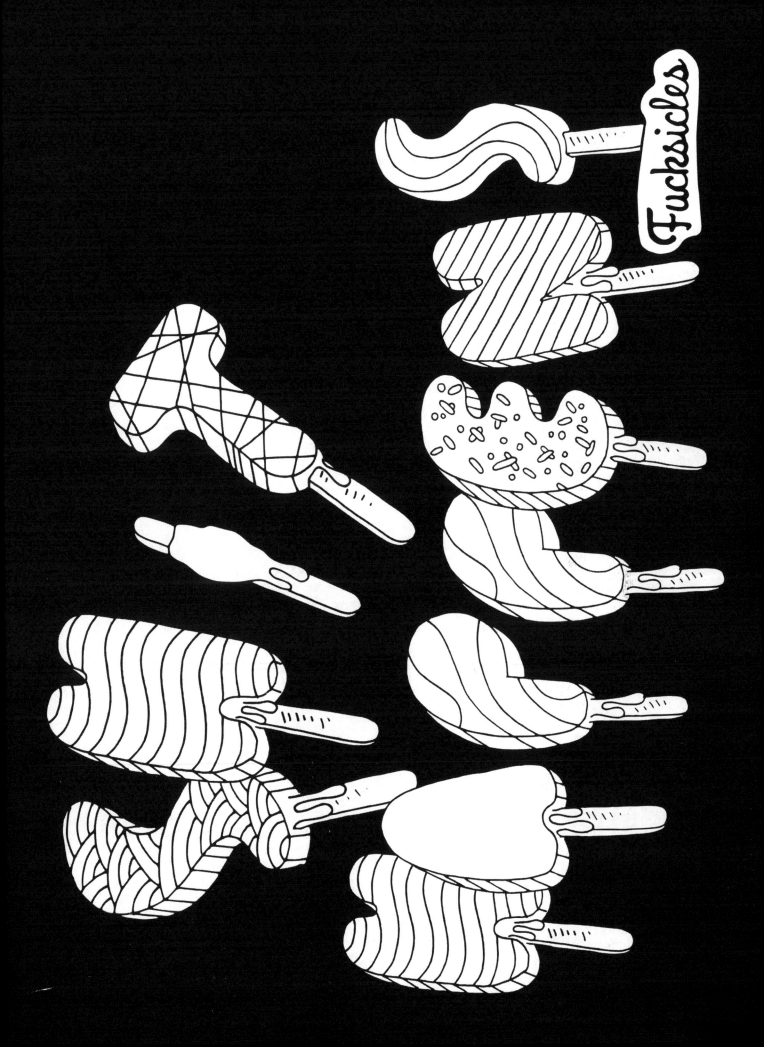

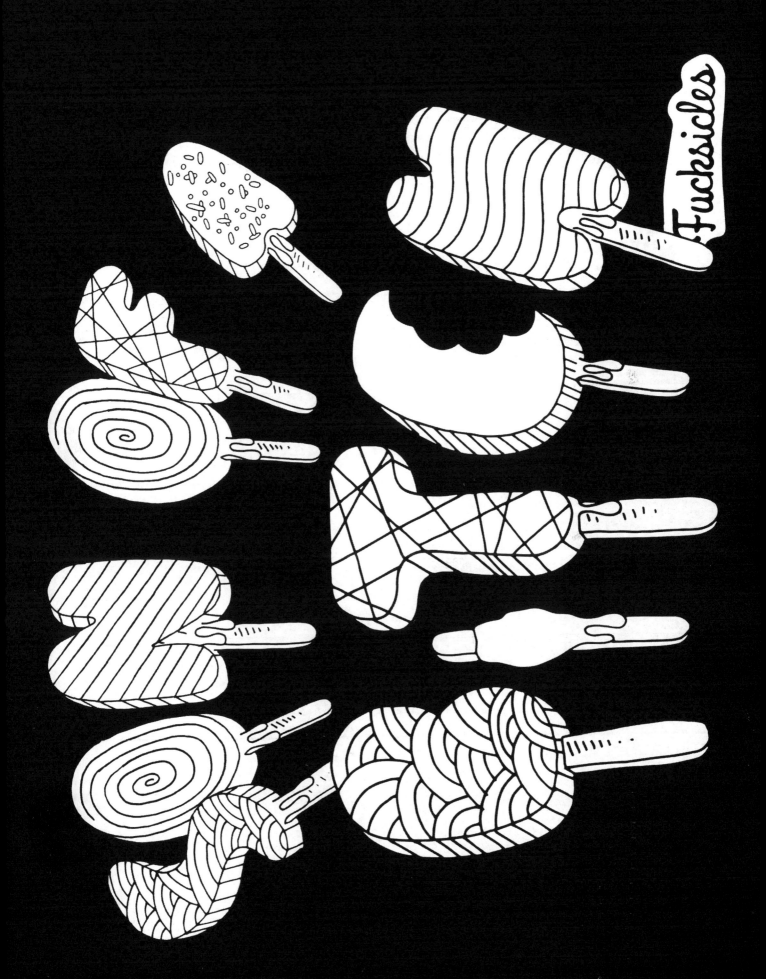

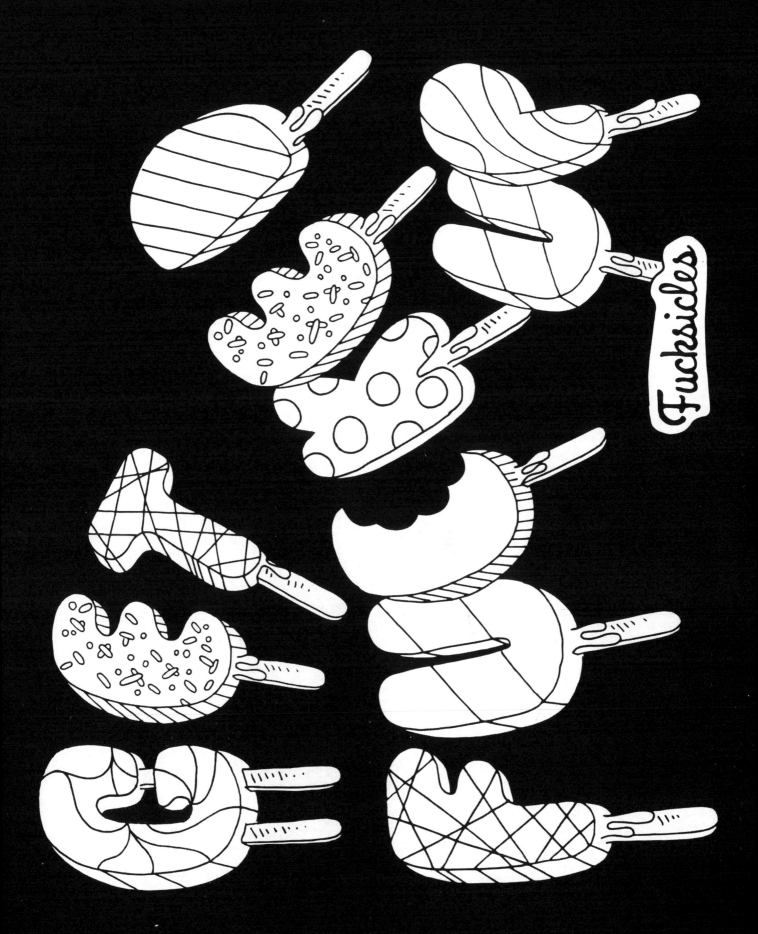

Fucksicles

Make everyday a fucksicle!

Sale ends this week!

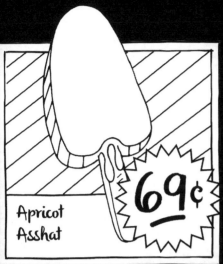

Apricot Asshat

69¢

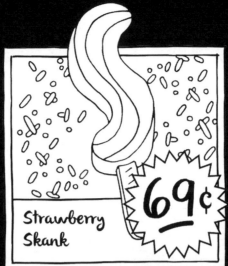

Strawberry Skank

69¢

Sea Salted Slut

69¢

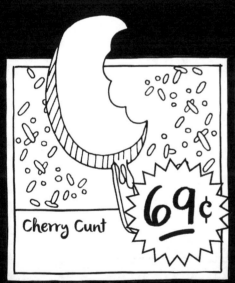

Cherry Cunt

69¢

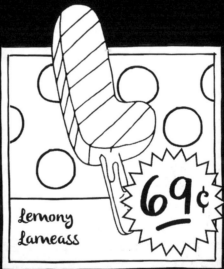

Lemony Lameass

69¢

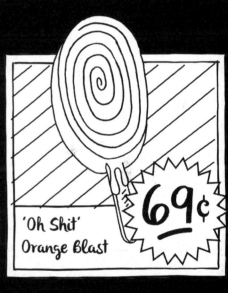

'Oh Shit' Orange Blast

69¢

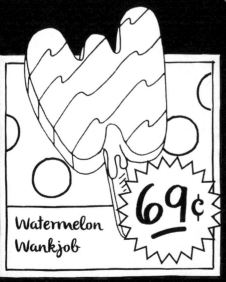

Watermelon Wankjob

69¢

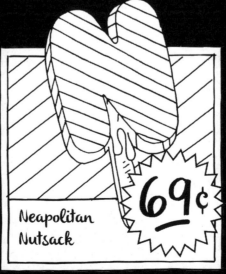

Neapolitan Nutsack

69¢

first come, first serve!

Get yours today!

Quantity is limited. At participating stores only. All other stores, fuck em!

Fucksicles

Keep it cool.

for that special occasion!

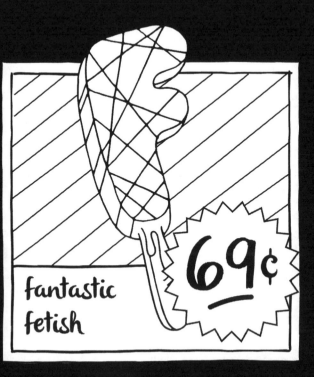

fantastic fetish

69¢

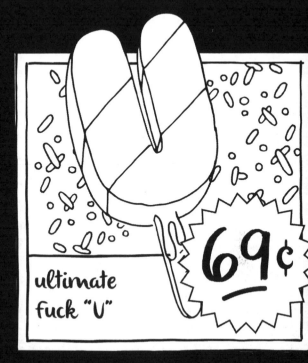

ultimate fuck "U"

69¢

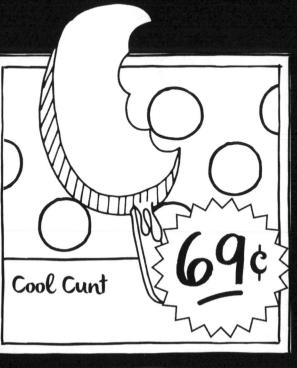

Cool Cunt

69¢

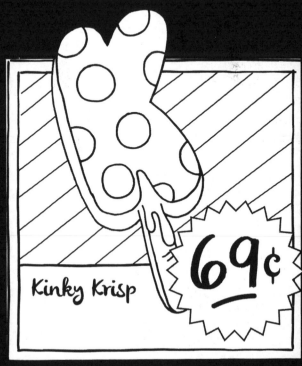

Kinky Krisp

69¢

Join the 'flavor of the month' club!

Fucksicles

3...2...1...fucksicle!

3 Brand new flavors!

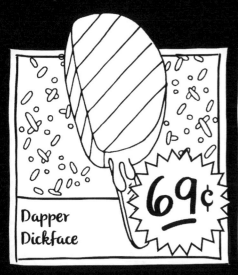
Dapper Dickface — 69¢

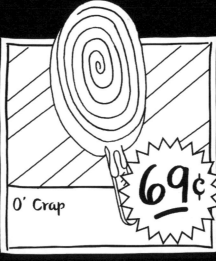
O' Crap — 69¢

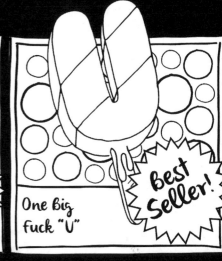
One Big Fuck "U" — Best Seller!

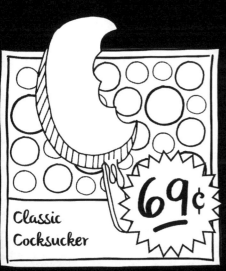
Classic Cocksucker — 69¢

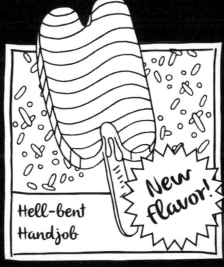
Hell-bent Handjob — New Flavor!

Egotistical Asshole — 69¢

Blueberry Bitch — New Flavor!

Alarming Assclown — 69¢

Grandiose Goober — New Flavor!

Quantity is limited. At participating stores only. All other stores, fuck em!

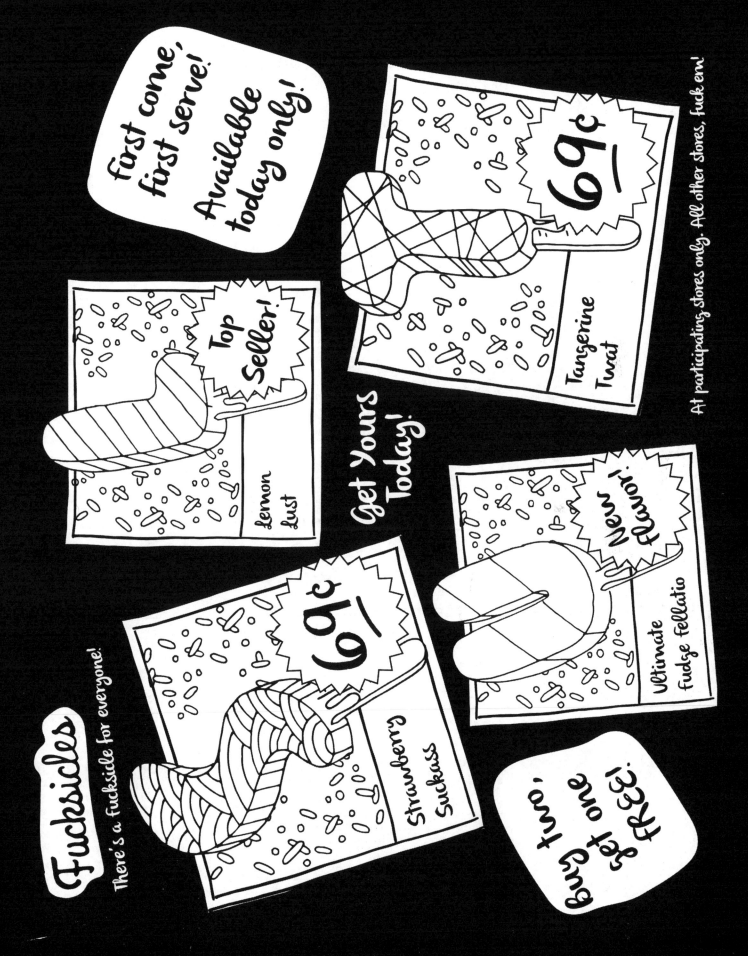

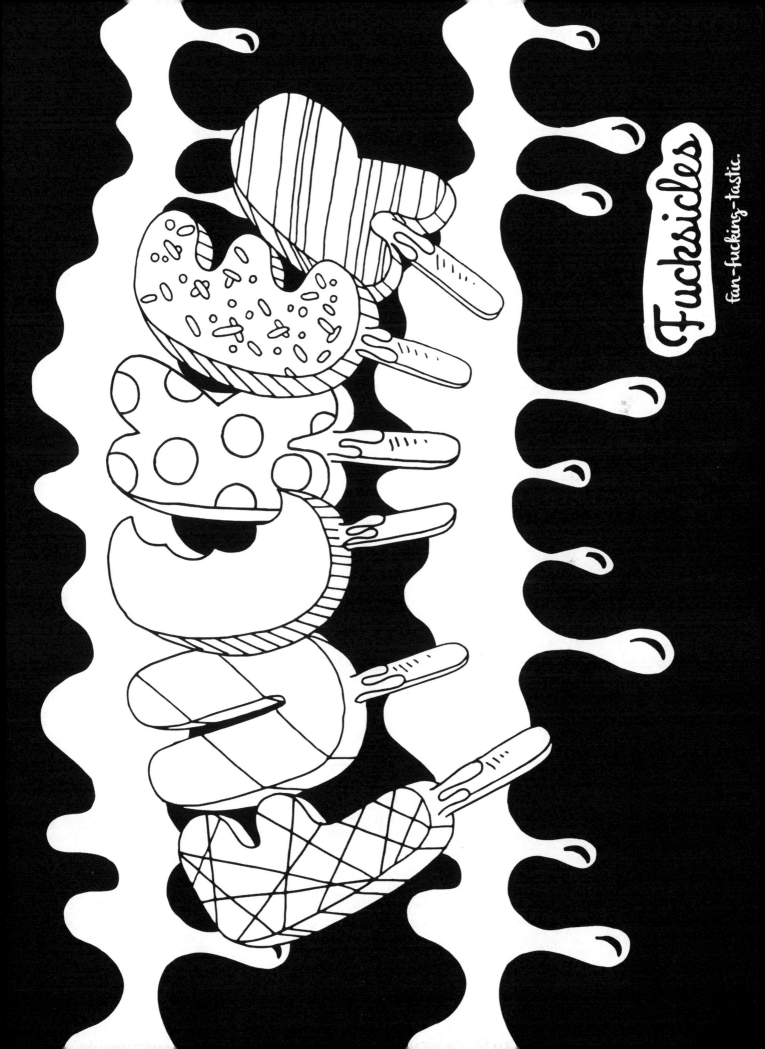

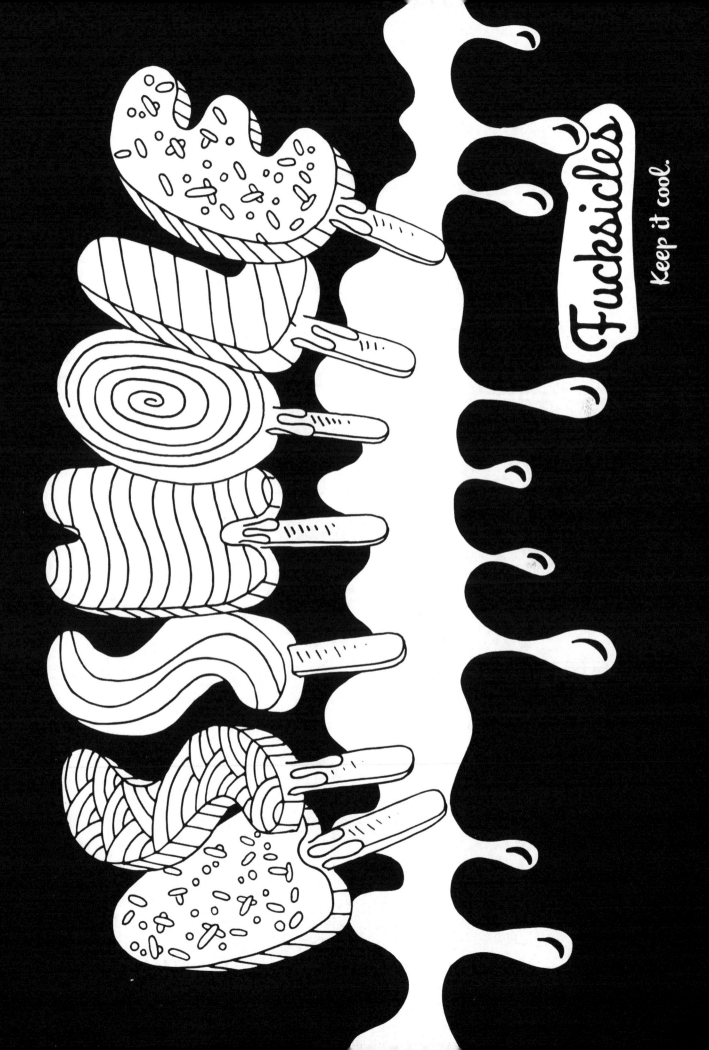

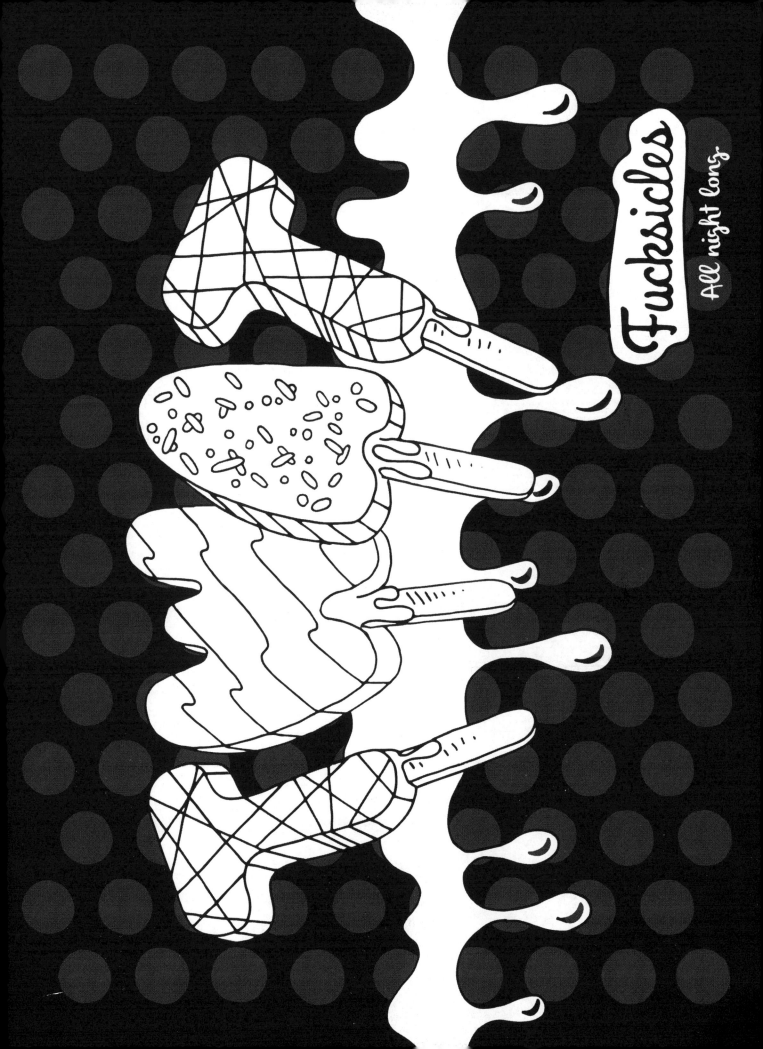

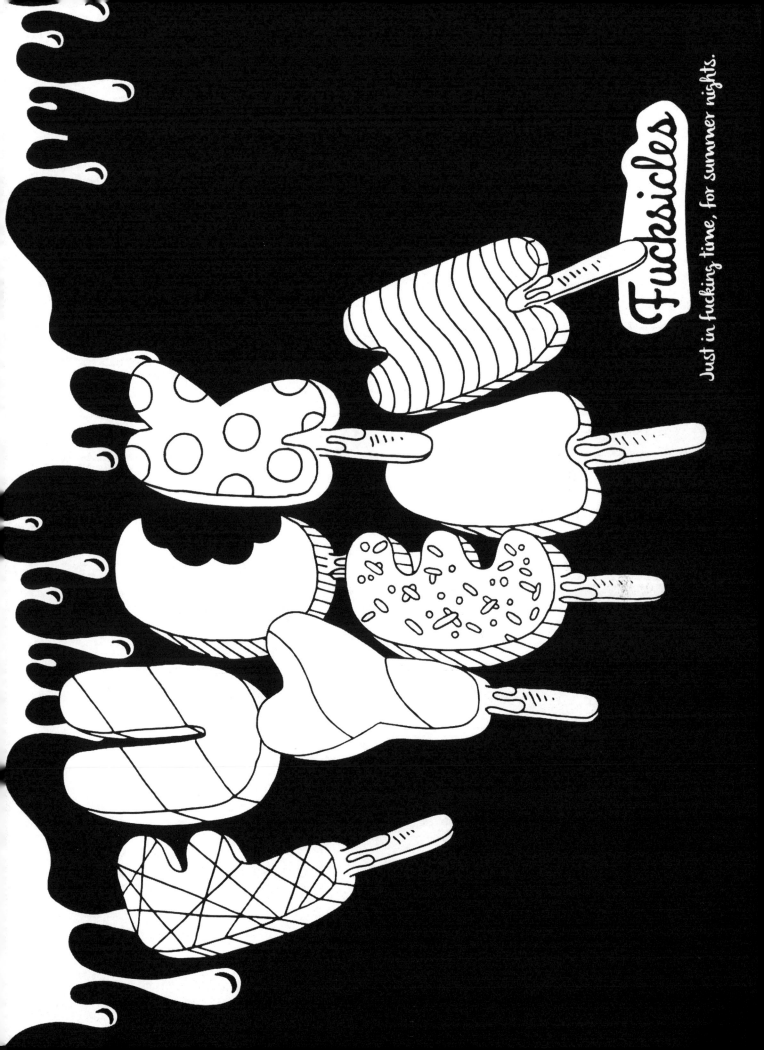

Fucksicles

Just in fucking time, for summer nights.

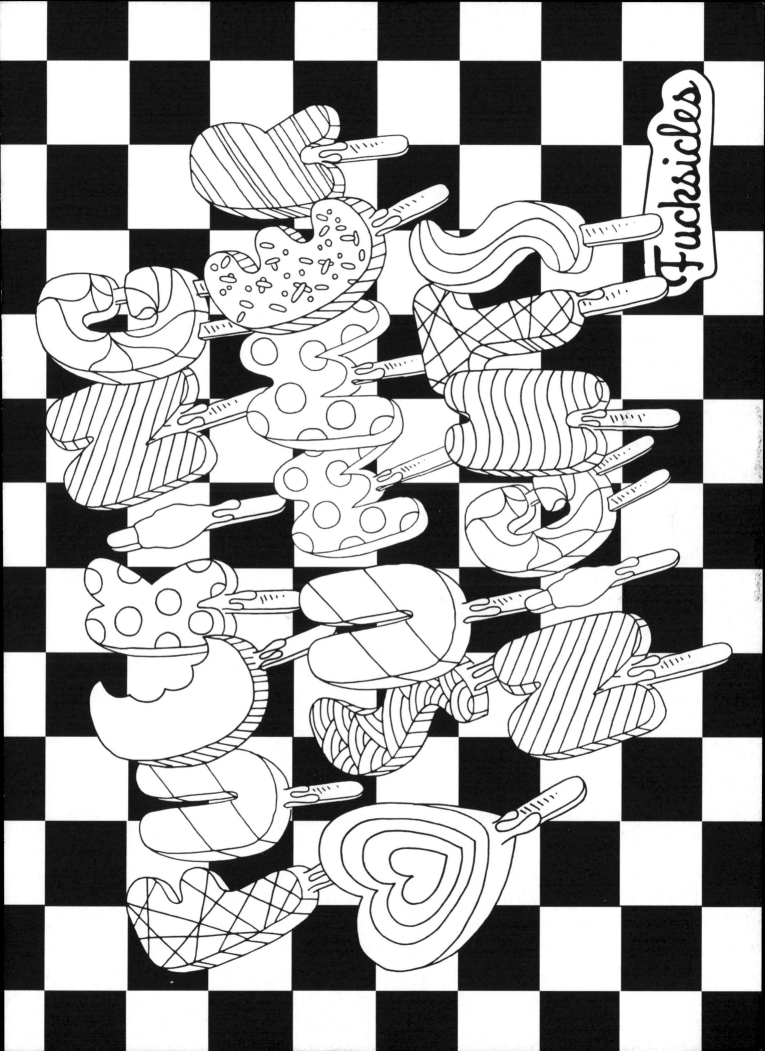

Fuck! Nothing left to color. But...